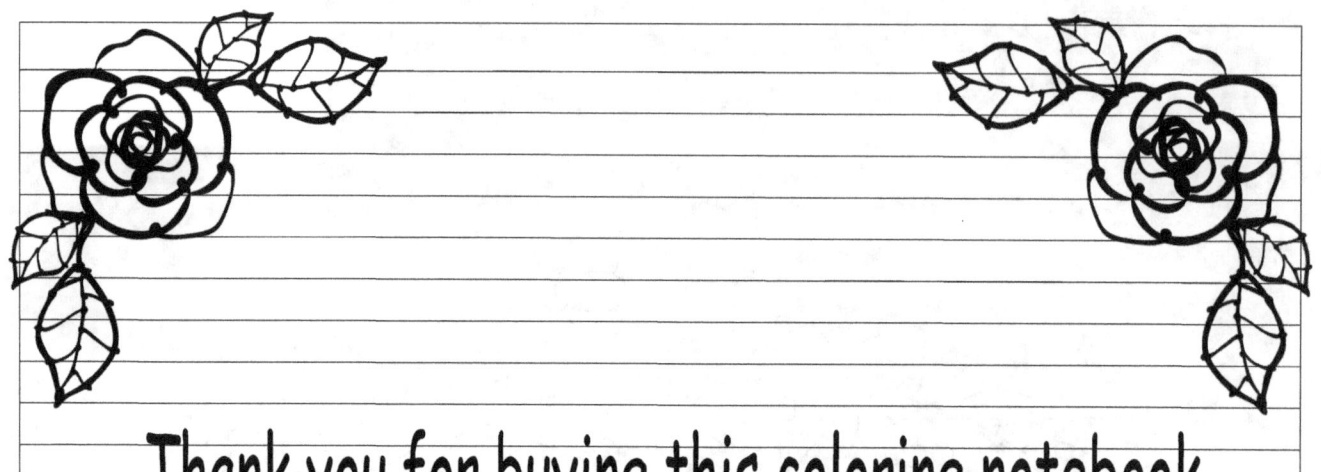

Thank you for buying this coloring notebook

This is a special coloring book.
There are many ways to use it.
When you are finished coloring then you can use it as a stationery or diary.
Please do not use too much ink to prevent the pigment from penetrating to the back.
It is recommended to use a color ballpoint and crayon or any color pen with less ink.

This coloring book has 40 pages.
40 exquisite rose patterns.
If you are a roses lover like I am
Then you will love this coloring book.
Behind each pattern is a note page for using
So, Just explore and enjoy these new designs.
Great as a gift for yourself. You will love it !

ROSE LOVE

Love Of Rose Coloring Notebook
ZAOMI LEAGUE

PUBLISHED BY: ZAOMI LEAGUE
Copyright © 2018
All rights reserved.

No part of this publication may be copied, reproduced in any format, by any means, electronic or otherwise, without prior consent from the copyright owner and publisher of this book.

Disclaimer

The information contained in this ebook is for general information purposes only. The information is provided by the authors and while we endeavor to keep the information up to date and correct, we make no representations or warranties of any kind, express or implied, about the completeness, accuracy, reliability, suitability or availability with respect to the ebook or the information, products, services, or related graphics contained in the ebook for any purpose. Any reliance you place on such information is therefore strictly at your own risk.

www.ingramcontent.com/pod-product-compliance
Lightning Source LLC
Chambersburg PA
CBHW081644220526
45468CB00009B/2548